ARTIST'S
LIBRARY
SERIES

D0534741

Creative Cartooning

By Tim van de Vall

www.walterfoster.com

Publisher: Rebecca J. Razo
Art Director: Shelley Baugh
Project Editor: Stephanie Meissner
Managing Editor: Karen Julian
Associate Editor: Jennifer Gaudet
Assistant Editor: Janessa Osle
Production Designers: Debbie Aiken, Amanda Tannen
Production Manager: Nicole Szawlowski
Production Coordinator: Lawrence Marquez

www.walterfoster.com
3 Wrigley, Suite A
Irvine, CA 92618

Printed in China
1 3 5 7 9 10 8 6 4 2
18701

TABLE OF CONTENTS

HOW TO DRAW CARTOONS

HELLO. I AM A CARTOON.

...IN PROGRESS.

YOU DON'T BELIEVE ME, DO YOU?

"YOU'RE NOT A CARTOON. YOU'RE JUST AN IMPERFECT CIRCLE."

TRUE, I AM ONLY AN IMPERFECT CIRCLE, BUT I AM ALSO THE BUILDING BLOCK OF ALMOST EVERY CARTOON. WATCH!

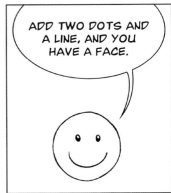

ADD TWO DOTS AND A LINE, AND YOU HAVE A FACE.

DRAW A LINE THROUGH ME, CALLED THE "LINE OF ACTION," AND YOU'VE GOT THE START OF A BODY!

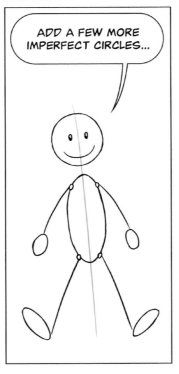

ADD A FEW MORE IMPERFECT CIRCLES...

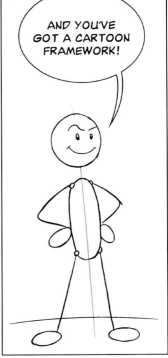

AND YOU'VE GOT A CARTOON FRAMEWORK!

TAKE A LOOK AT ALL THE POSES I CAN DO WITH ONLY A SINGLE LINE OF ACTION AND THE SIMPLE REARRANGEMENT OF MY FACE AND LIMBS.

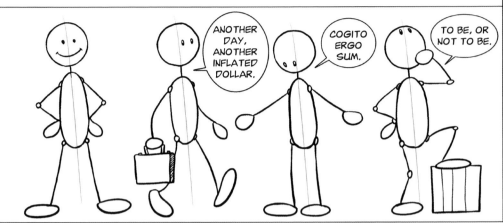

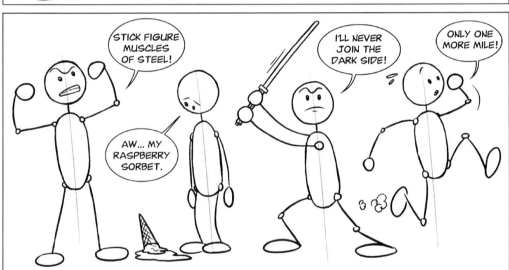

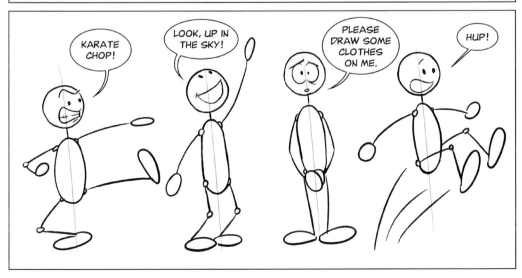

ALL THE POSES ON THE PREVIOUS PAGE WERE MADE WITH THE SAME LINE OF ACTION. WHAT HAPPENS IF YOU CHANGE THE LINE OF ACTION A BIT?

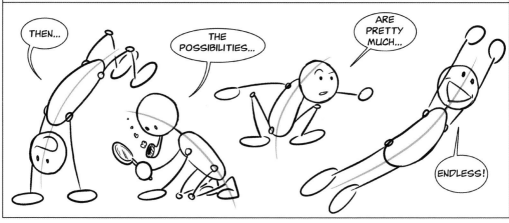

NOW WE HAVE A FRAMEWORK. NATURALLY, A FRAMEWORK NEEDS TO BE COVERED.

IF I MAY...

I'M FEELING PRETTY GOOD ABOUT THIS.

STILL, WE'VE GOT A LONG WAY TO GO BEFORE I'M COMPLETE. FOR INSTANCE, I WOULDN'T MIND HAVING ACTUAL HANDS. LET'S DRAW SOME!

START BY DRAWING A CIRCLE. (BET YOU DIDN'T SEE THAT COMING.)

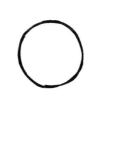

NOW ADD SOME FINGERS. THREE SHOULD BE ENOUGH.

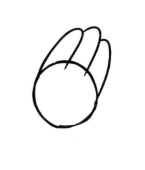

FINALLY POP ON A THUMB, THROW IN A FEW MORE LINES, AND VOILÀ! CARTOON HANDS!

AH, IT'S GOOD TO HAVE OPPOSABLE THUMBS.

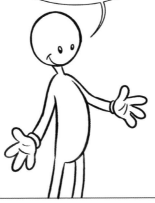

OF COURSE, HANDS CAN MAKE ALL SORTS OF GESTURES. WHY DON'T WE GO OVER A FEW?

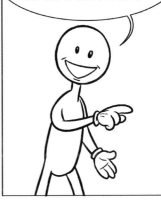

PRACTICE DRAWING THESE GESTURES A FEW TIMES.
YOU'LL BE AN EXPERT BEFORE YOU KNOW IT!

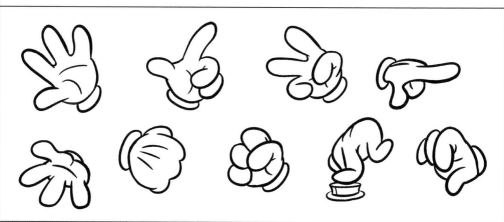

OK, LET'S COMBINE EVERYTHING WE'VE LEARNED SO FAR.

THANKS TO IMPERFECT CIRCLES, THE LINE OF ACTION, AND A COVERED FRAMEWORK, WE CAN NOW DRAW...

... A BRISK TROT.

... A SPEEDY FLIGHT.

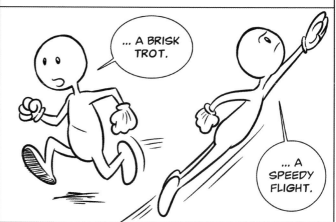

... AN ACROBATIC STUNT.

... A GRACEFUL DANCE.

... OR A LONG JUMP.

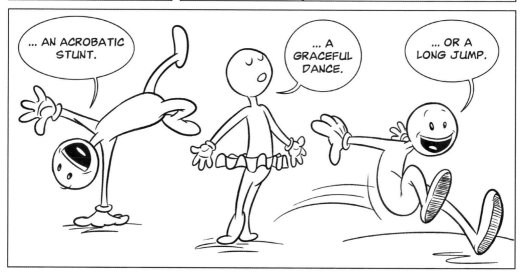

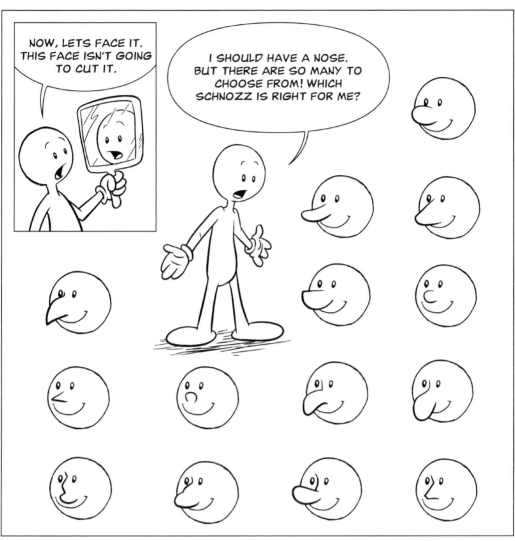

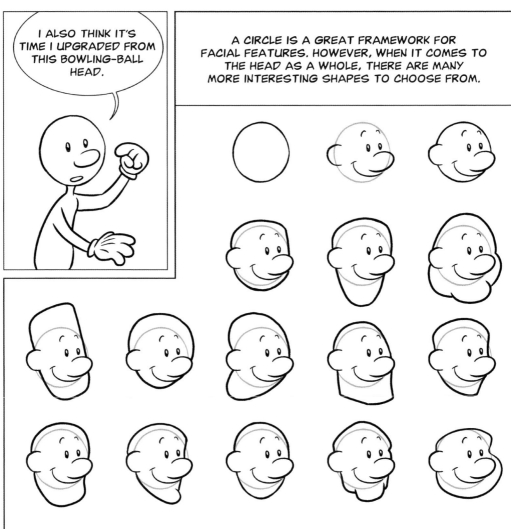

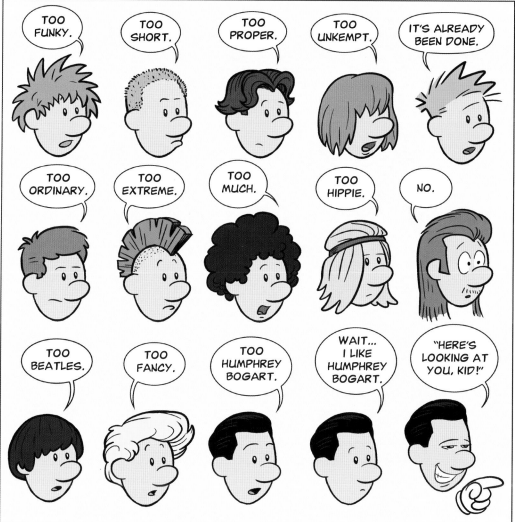

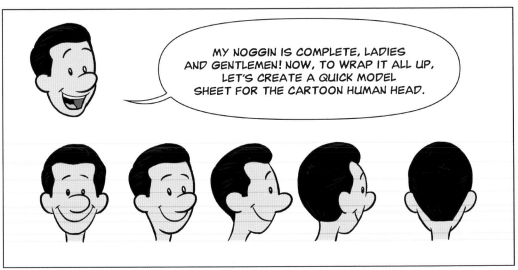

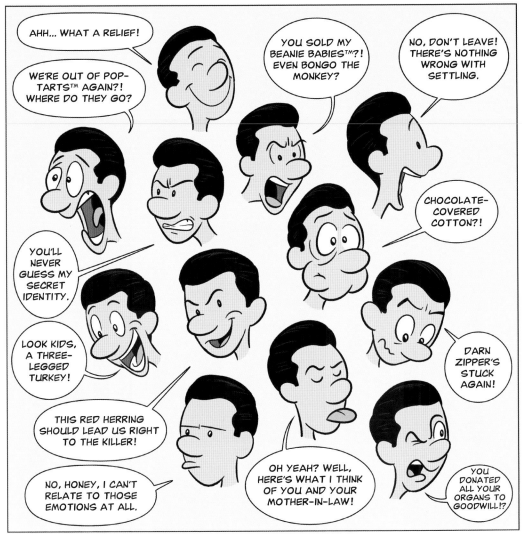

MOVING ON... LET'S TAKE A LOOK AT CARTOON BODY TYPES. AFTER ALL, THIS BODY ISN'T THE ONLY OPTION.

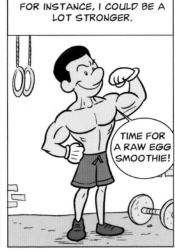

FOR INSTANCE, I COULD BE A LOT STRONGER.

TIME FOR A RAW EGG SMOOTHIE!

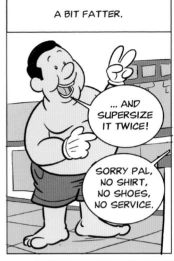

A BIT FATTER.

... AND SUPERSIZE IT TWICE!

SORRY PAL, NO SHIRT, NO SHOES, NO SERVICE.

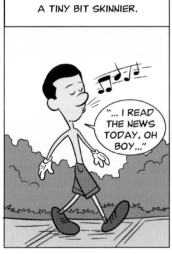

A TINY BIT SKINNIER.

"... I READ THE NEWS TODAY, OH BOY..."

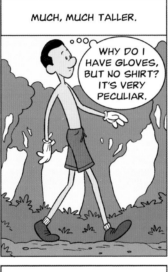

MUCH, MUCH TALLER.

WHY DO I HAVE GLOVES, BUT NO SHIRT? IT'S VERY PECULIAR.

A GREAT DEAL DENSER.

WHOEVER WINS GETS TO WHACK THE LOSER WITH A RACKET!

MORE REALISTIC.

I'VE GOTTEN SO MUCH BETTER SINCE I STARTED PLAYING ON THE KID'S COURT

OR EVEN LESS.

GEE WILLIKERS, ARE THESE PANTS SWELL!

EH... YOU KNOW WHAT? I THINK I'LL SKIP THE PLASTIC SURGERY FOR NOW AND JUST KEEP THE BODY I HAVE.

WELL, IT LOOKS LIKE I'M ALL SET! I'M OFF TO SEEK MY FORTUNE IN THE CARTOON WORLD!

FAME, FORTUNE, FAST CARS, AND PRETTY GIRLS ARE ALL WAITING FOR ME JUST BEYOND THE HORIZON.

COME TO THINK OF IT, WHERE THE HECK IS THE HORIZON?

THIS CARTOON WORLD IS COMPLETELY EMPTY!

WHERE ARE THE CARS? THE HOUSES? THE GIRLS?

WE'RE GOING TO SHOW OUR READERS HOW TO DRAW THOSE THINGS, RIGHT AFTER THE TOOLS & MATERIALS SECTION.

THIS SOUNDS LIKE WORK.

GET UP.

CARTOONING TOOLS & MATERIALS

WHAT'S THIS?

A SHOPPING LIST.

ART SUPPLIES? WHERE CAN I BUY ART SUPPLIES IN A WORLD THAT DOESN'T EVEN HAVE A HORIZON LINE?

YOU'RE GOING TO VISIT THE ART STORE I JUST DREW FOR YOU.

AND HOW AM I GOING TO GET THERE WITHOUT A CAR?

I ALSO DREW YOU A CAR.

I HATE ANTHROPOMORPHIC AUTOMOBILES!

MY NAME IS BUCKY!

Cartoonist's Shopping List

Traditional Tools:
Pencils
 Lead grades 4H-HB, F, B-4B
 Mechanical pencils
Pens
 Pigment liners
 1.0 Gel ink pens
Electric Sharpener
Paper
 11" x 17" 150-lb. paper
 Sketch pad
 Tracing paper
India ink
Synthetic watercolor brushes
Drawing table
Erasers
 Retractable erasers
 Large erasers
Light table
Pen nibs & nib holders

Digital Tools (optional):
Computer
11" x 17" scanner/printer
9" x 12" drawing tablet
Adobe® Creative Suite®
 Photoshop®
 Illustrator®
Manga Studio®
Internet connection

WHY DON'T YOU EXPLAIN ABOUT ALL THIS STUFF WHILE I'M DRIVING?

GOOD IDEA.

ART SUPPLY

OPEN

PENCILS

Pencils come in a wide range of lead grades. Leads grades determine the hardness or softness of a lead.

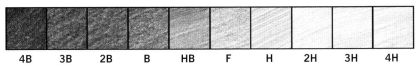

| 4B | 3B | 2B | B | HB | F | H | 2H | 3H | 4H |

For initial pencil sketches, harder leads provide a light stroke that's easy to erase. I like to start a drawing with a 4H pencil. Then, when I'm ready to finalize the lines, I go over them with a softer pencil for a darker stroke.

You may also want to try mechanical pencils. I prefer to use these for inorganic objects and backgrounds, since they provide a uniform stroke width.

ART SUPPLY

OPEN

PENS

1.0 PIGMENT LINER

Pens are great for inking backgrounds and objects with less line-width variation. Experiment with different pigment liners to find the kind you like best.

PAPER

I recommend purchasing a sketch pad for doodles and early concepts. For final pencil work, I prefer 11" x 17" 150-lb. paper. The high paper weight prevents ink from bleeding. Tracing paper is a great tool if you like to work iteratively.

ERASERS

For erasing details, I recommend a retractable eraser. For erasing larger areas, plastic erasers work well. There are many quality brands available. Just test that the eraser won't stain the paper.

WE'RE ALREADY AT THE END OF THE PAGE, AND I'VE BARELY MOVED 2 INCHES!

I ONLY HAVE A 49CC ENGINE.

ART SUPPLY

OPEN

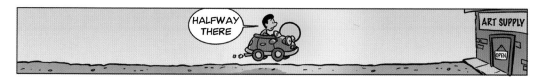

BRUSHES, NIBS, AND INK

Use india ink to ink cartoons. Traditionally, cartoons can be inked with either brushes or nibs. I recommend using either a high-quality, synthetic watercolor brush or a flexible quill nib.

DRAWING TABLE

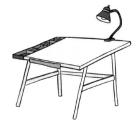

If you plan to draw for extended periods of time, you may want to consider purchasing a drawing table. The angled surface will help keep your back straight while you draw.

LIGHT TABLE

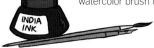

Like tracing paper, a light table allows you to easily copy your own work. This is useful for transferring pencil sketches onto thicker paper for final cartoon drawings.

COMPUTER

If you plan to create digital art, you need a computer. Most of my cartoons, including those in this book, are created on a laptop, using a drawing tablet and stylus.

TABLET

With a drawing tablet and stylus, you can draw right on your computer. I use my tablet predominantly for inking and coloring.

SOFTWARE

Adobe Photoshop is a great tool for coloring cartoons. Adobe Illustrator is useful for lettering and producing vector art. For digital inking, I use Manga Studio.

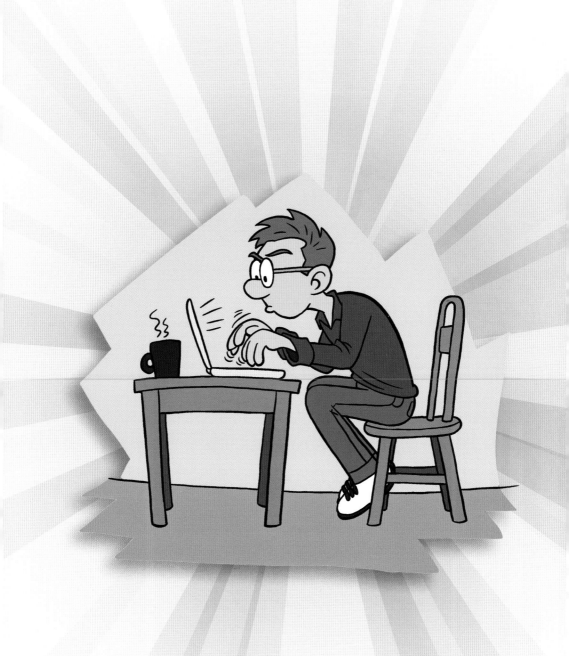

HOW TO DRAW THE MODERN FAMILY

DOG

DIFFICULTY LEVEL: ★★☆☆☆

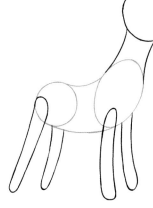

STEP 1 Draw a circle and an oval for the dog's hips and upper body. Then draw curved connecting lines.

STEP 2 Extend the neck from the upper body. At the top of the neck, draw another circle. Then draw the dog's legs. I just use long, rounded shapes.

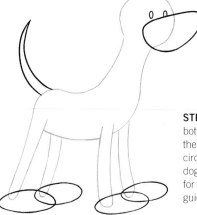

STEP 3 Add oval feet to the bottom of the legs. Stick a tail on the dog, extending from the hip circle. Then place a snout on the dog's head. Add two small ovals for eyes. As you work, erase the guidelines you no longer need.

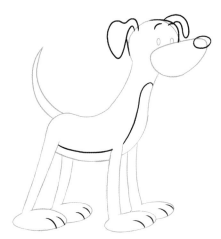

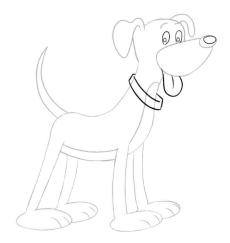

STEP 4 Add another oval for the nose. Draw a set of ears on the head. And some lines on the feet for toes. Include a line to partition the underbelly from the rest of the body.

STEP 5 Pencil in the whites of the eyes and a highlight for the nose. Then give the pup a collar and tongue.

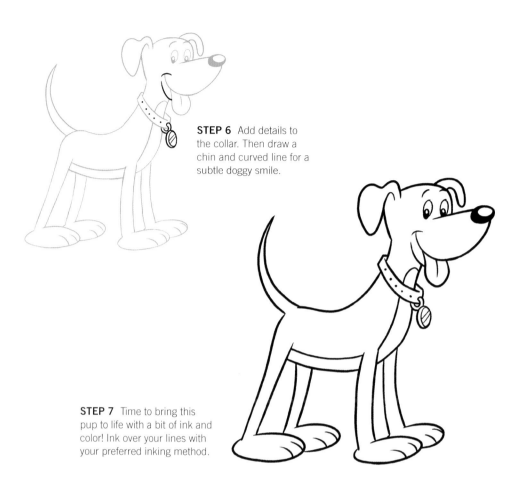

STEP 6 Add details to the collar. Then draw a chin and curved line for a subtle doggy smile.

STEP 7 Time to bring this pup to life with a bit of ink and color! Ink over your lines with your preferred inking method.

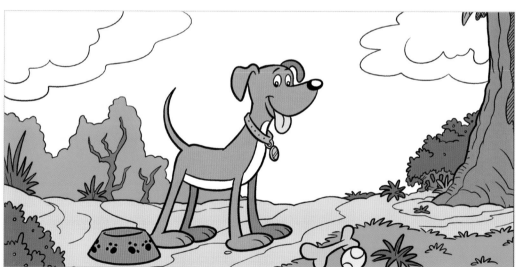

STEP 8 Add color, either digitally or with traditional tools. Congratulations! Your cartoon dog is complete. Add some background details and doggy toys for him to play with.

GIRL

DIFFICULTY LEVEL: ★★★☆☆

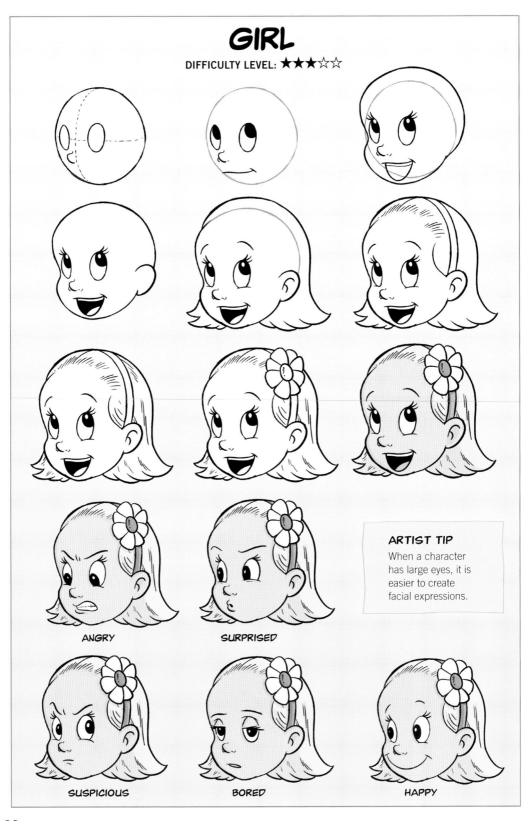

ANGRY

SURPRISED

ARTIST TIP

When a character has large eyes, it is easier to create facial expressions.

SUSPICIOUS

BORED

HAPPY

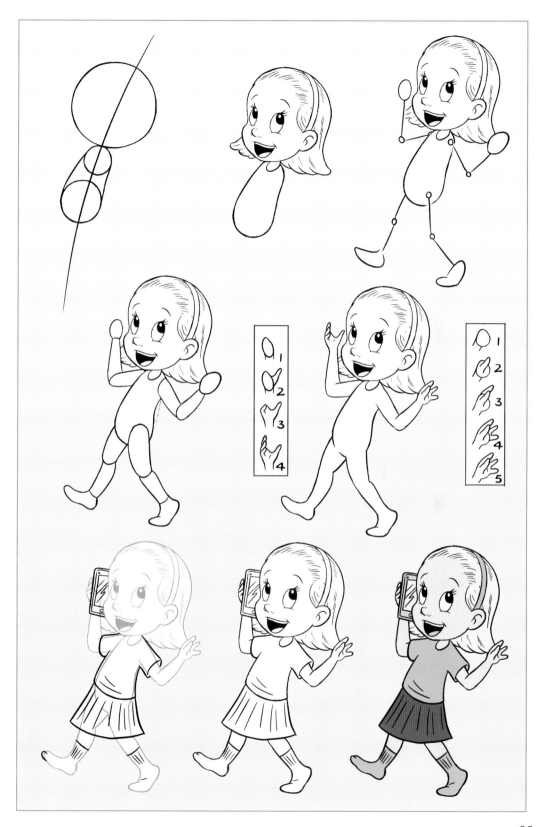

MOM

DIFFICULTY LEVEL: ★★★☆☆

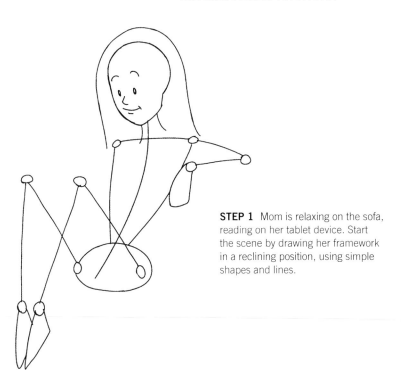

STEP 1 Mom is relaxing on the sofa, reading on her tablet device. Start the scene by drawing her framework in a reclining position, using simple shapes and lines.

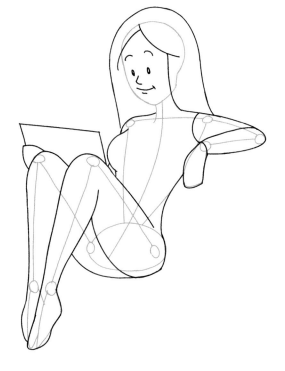

STEP 2 Draw the outline of her body around the framework.

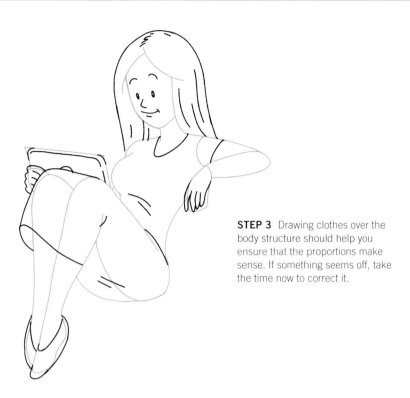

STEP 3 Drawing clothes over the body structure should help you ensure that the proportions make sense. If something seems off, take the time now to correct it.

STEP 4 Now draw the couch where Mom is relaxing.

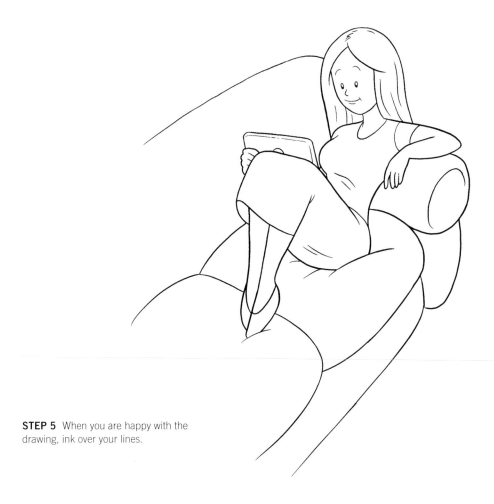

STEP 5 When you are happy with the drawing, ink over your lines.

PRACTICE EXERCISES

PROP SWITCH Draw Mom reading a book instead of a tablet.

CHARACTER CAMEO Draw the family dog (see pages 20 and 21) lying on the couch next to Mom.

A NEW HAIRSTYLE Give Mom a ponytail.

COMPLETE THE SCENE Draw part of the room around the couch. Include a side table with a lamp, a coffee table, and a few paintings on the walls.

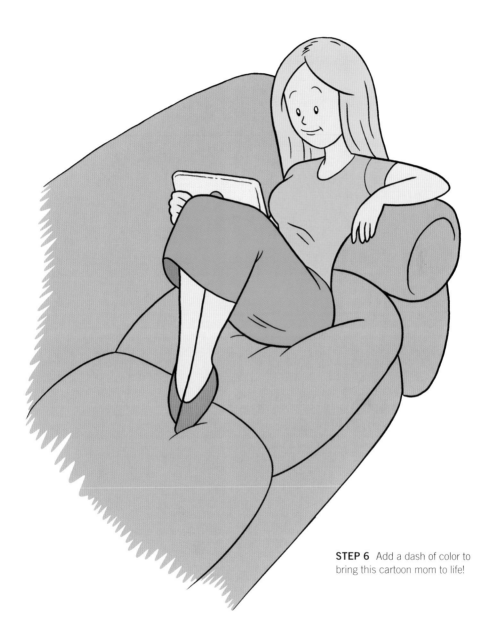

STEP 6 Add a dash of color to bring this cartoon mom to life!

BOY

DIFFICULTY LEVEL: ★★★☆☆

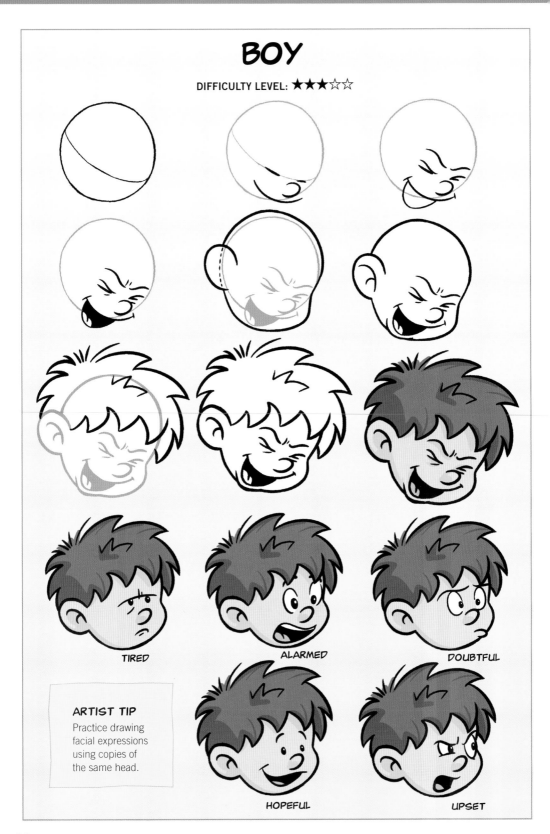

TIRED

ALARMED

DOUBTFUL

ARTIST TIP
Practice drawing facial expressions using copies of the same head.

HOPEFUL

UPSET

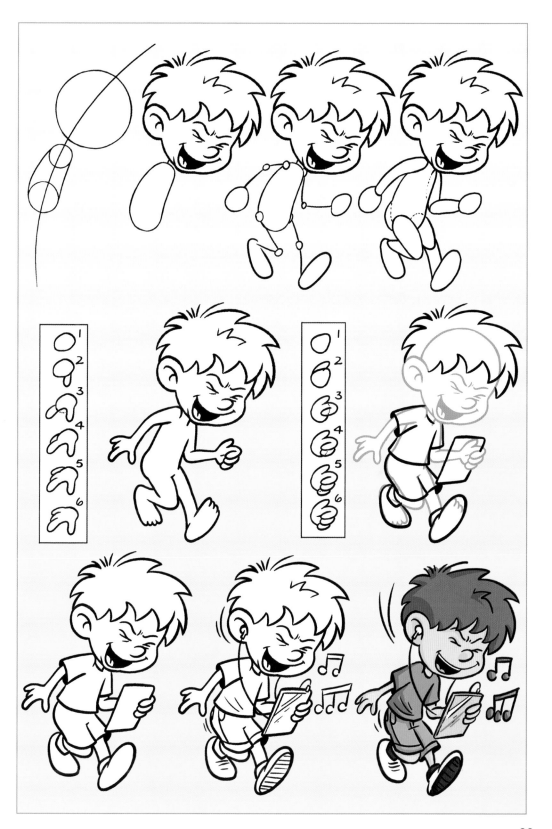

DAD

DIFFICULTY LEVEL: ★★☆☆☆

STEP 1 Begin by drawing a simple table and chair. Because Dad will be sitting on the chair and working at the table, it is important to draw these props first. You can use a horizontal dotted line to make sure the objects in the drawing are level. Use simple shapes to add the torso and head.

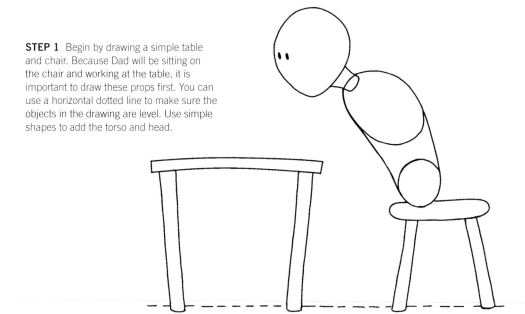

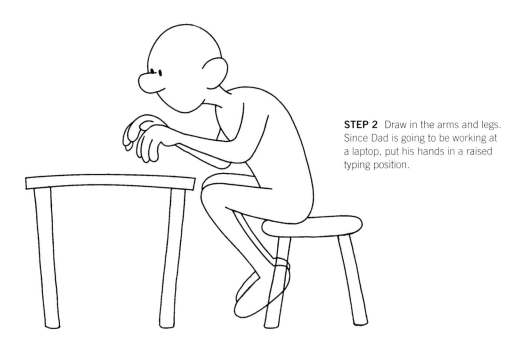

STEP 2 Draw in the arms and legs. Since Dad is going to be working at a laptop, put his hands in a raised typing position.

30

STEP 3 Now add some clothes. Stern eyebrows show that the character is focused on his work.

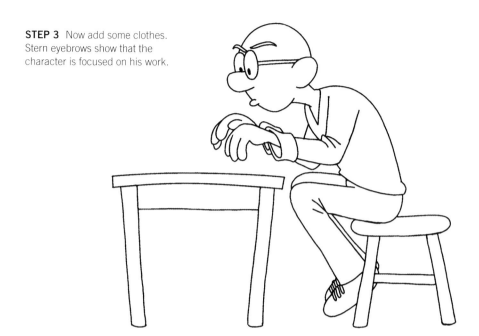

STEP 4 Finish the illustration by adding in the final details and props.

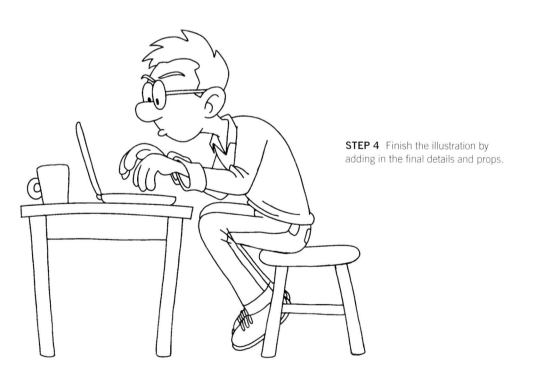

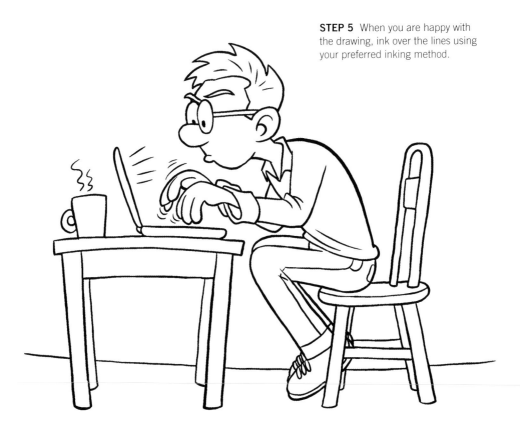

STEP 5 When you are happy with the drawing, ink over the lines using your preferred inking method.

DIGITAL INKING TECHNIQUES

I start by outlining the drawing with my thickest digital brush. The width changes depending on how much pressure I apply on my tablet.

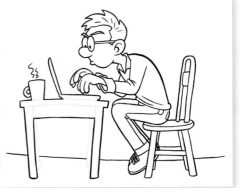

Working from the outside in, I use a small brush to ink the interior lines. Sometimes I use an even smaller brush to add small details like texture.

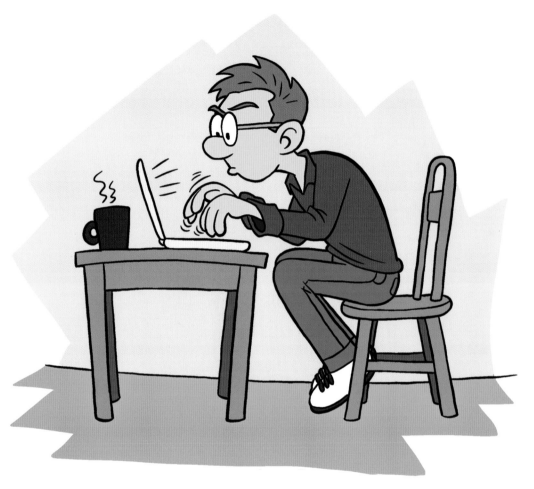

STEP 6 Finish by adding color.

PRACTICE EXERCISES

A CHANGE IN PERSPECTIVE Draw the same scene from a different angle.

POSTURE REDO Keep the chair and table as they are. Draw Dad again, but sitting back in his chair sipping from his coffee mug.

PROP SWITCH Draw Dad working at a typewriter instead of a computer.

COLOR CORRECTION Recolor the drawing, making sure to pick colors that complement one another.

HOW TO DRAW
PIRATES

PIRATE

DIFFICULTY LEVEL: ★★☆☆☆

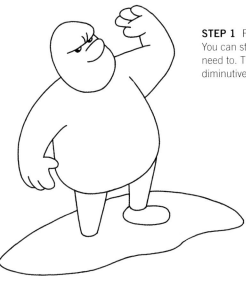

STEP 1 First draw a basic body structure. You can start with shapes and lines first if you need to. The pirate's Neanderthal forehead and diminutive eyes show that he is a dim brute.

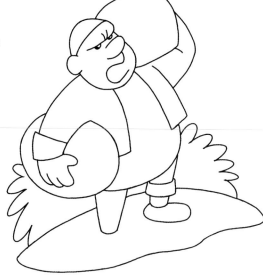

STEP 2 Next add some important props. The character in this scene is carrying a barrel and a sea chest. Drawing the pirate's left hand in step 1 makes it easier to achieve accurate structure and proportions when you add the chest.

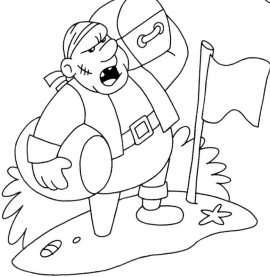

STEP 3 Complete the pirate's face, and draw a flag in the sand.

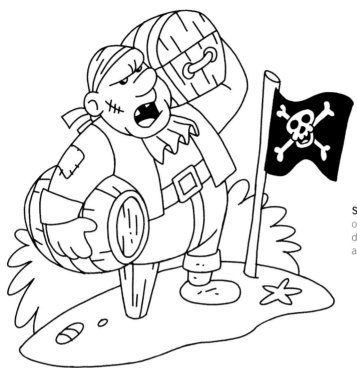

STEP 4 Now that all the key parts of the drawing are in place, add details to the flag, chest and barrel, and peg leg.

DIGITAL COLORING TECHNIQUES

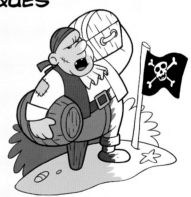

When coloring a cartoon on the computer with a program such as Photoshop, keep the inking and coloring on two separate layers. Layers are like digital tracing paper.

Keep the inking layer above the coloring layer, and you'll never paint over your lines. If your inking layer contains both black and white pixels, set your layer mode to "Multiply." This will make the white parts of the drawing transparent, so that the color can show through.

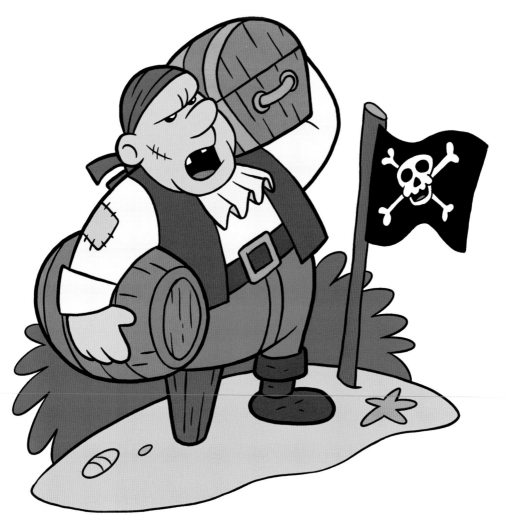

STEP 5 Ink over your drawing. Then add color, using the medium of your choice. Congratulations...this cartoon pirate is ready to sail the seven seas!

PRACTICE EXERCISES

NEW PIRATE DRESS CODE Draw the pirate with the following changes: Draw a boot instead of a peg leg, add a beard and mustache, and change the emblem on the flag from a Jolly Roger to a pair of crossed cutlasses.

EXPERIMENTS IN INKING Try inking the pirate illustration using a tool you are unfamiliar with. If you typically ink digitally, try using a traditional medium, and vice versa.

COLOR 2.0 Take the drawing to the next level by adding shadows.

POLLY WANTS A PART Draw the cartoon pirate with a parrot on his left shoulder instead of a treasure chest.

PIRATE PRINCESS

DIFFICULTY LEVEL: ★★★★★

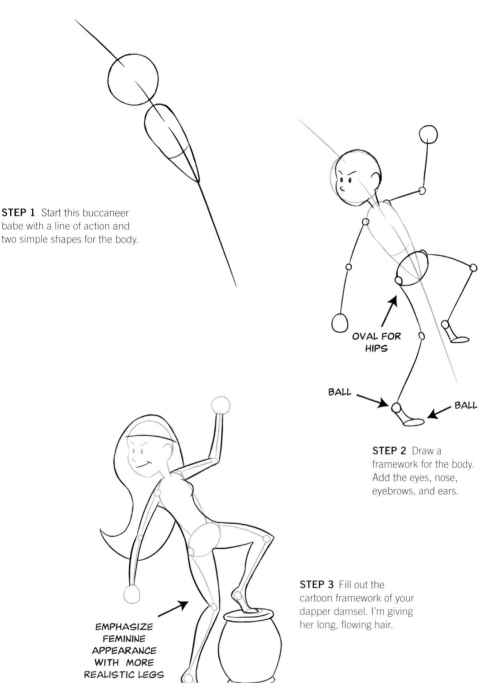

STEP 1 Start this buccaneer babe with a line of action and two simple shapes for the body.

OVAL FOR HIPS

BALL

BALL

STEP 2 Draw a framework for the body. Add the eyes, nose, eyebrows, and ears.

EMPHASIZE FEMININE APPEARANCE WITH MORE REALISTIC LEGS

STEP 3 Fill out the cartoon framework of your dapper damsel. I'm giving her long, flowing hair.

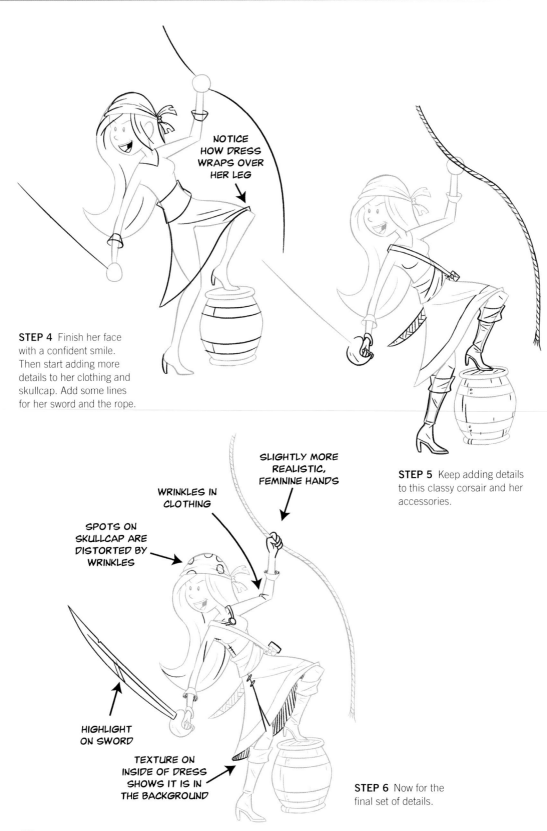

NOTICE HOW DRESS WRAPS OVER HER LEG

STEP 4 Finish her face with a confident smile. Then start adding more details to her clothing and skullcap. Add some lines for her sword and the rope.

STEP 5 Keep adding details to this classy corsair and her accessories.

SLIGHTLY MORE REALISTIC, FEMININE HANDS

WRINKLES IN CLOTHING

SPOTS ON SKULLCAP ARE DISTORTED BY WRINKLES

HIGHLIGHT ON SWORD

TEXTURE ON INSIDE OF DRESS SHOWS IT IS IN THE BACKGROUND

STEP 6 Now for the final set of details.

STEP 7 Time to ink our pirate princess. Then add a bit of color, and she's ready to plunder the high seas!

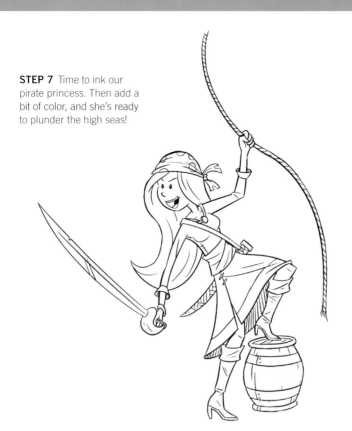

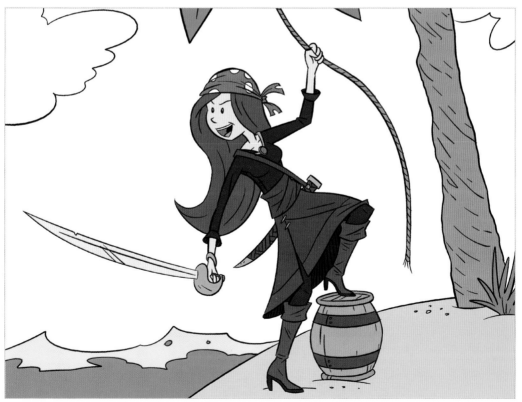

TREASURE CHEST

DIFFICULTY LEVEL: ★☆☆☆☆

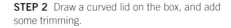

STEP 1 Start the treasure chest by drawing a simple rectangular box.

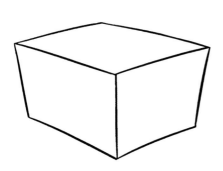

STEP 2 Draw a curved lid on the box, and add some trimming.

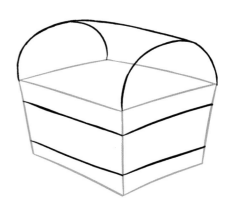

STEP 3 Erase the guidelines from the rectangle. Draw a lock and handle. Add the trim that goes over the lid.

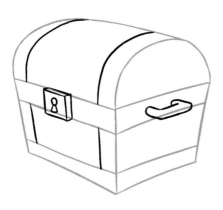

STEP 4 Next draw the wood slats and the circular rivets on the side.

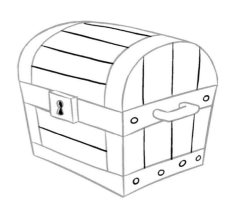

STEP 5 Finish up the rivets on the treasure chest.

STEP 6 Use short, sweeping strokes to add some detail to the wood.

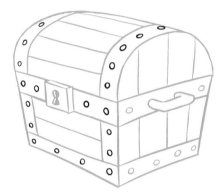

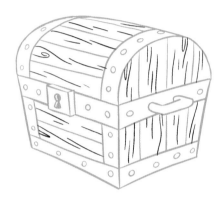

STEP 7 Ink your treasure chest with your preferred method and add color.

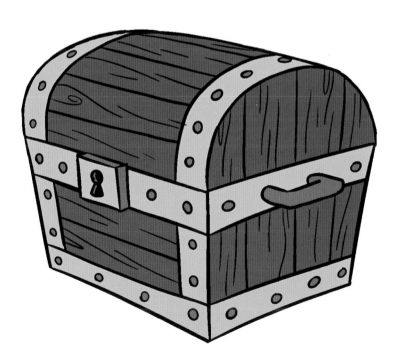

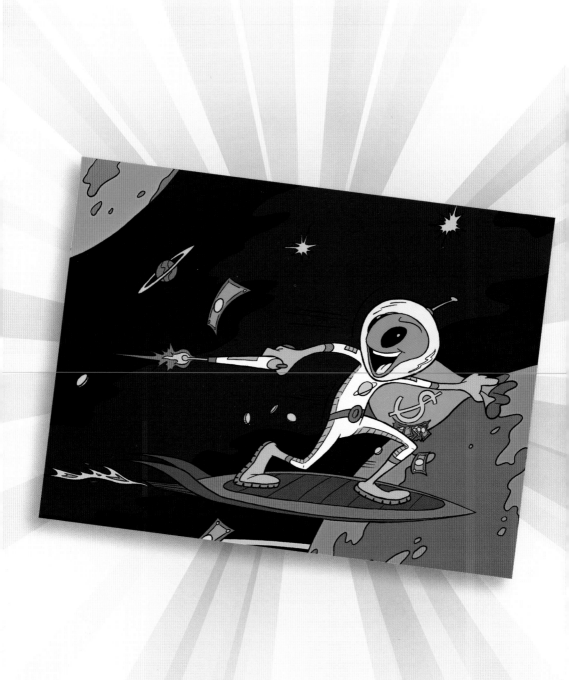

HOW TO DRAW OUTER SPACE CHARACTERS

SPACE ALIEN

DIFFICULTY LEVEL: ★★★★☆

STEP 1 Sketch a line of action, a circle for the head, and an oval for the body.

STEP 2 Complete the framework by adding lines for the limbs and placeholder shapes for the hands and feet. Then add the dark eyes.

STEP 3 With a few simple lines, transform the alien's stoic expression into one of mischievous confidence. Fill out the framework with smooth organic lines.

STEP 4 Give the space alien a mouth. Draw in the hands, the barrel of the ray gun, and the soles of his boots.

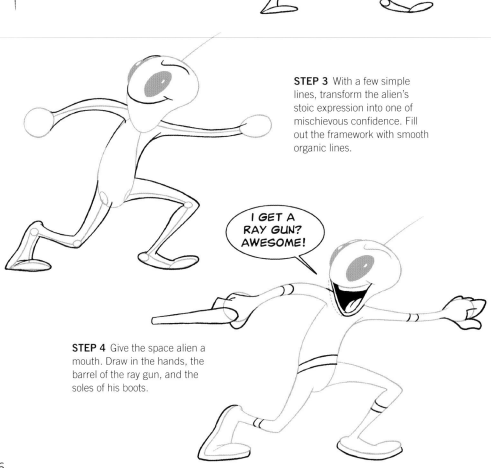

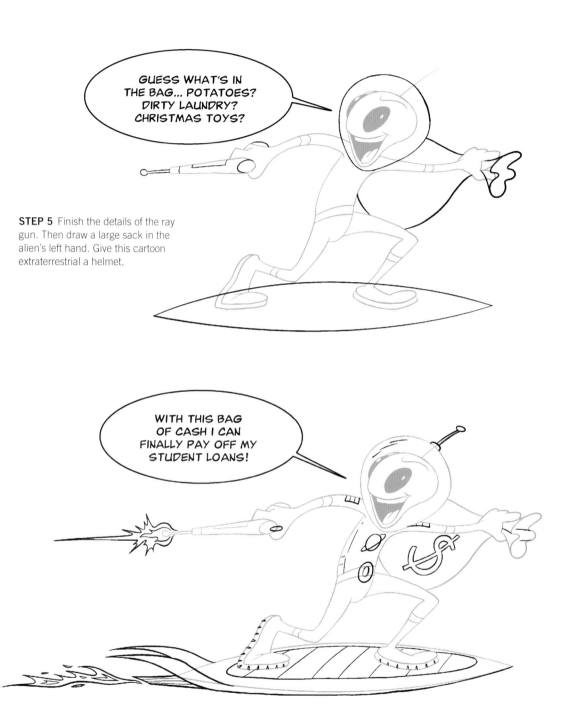

STEP 5 Finish the details of the ray gun. Then draw a large sack in the alien's left hand. Give this cartoon extraterrestrial a helmet.

STEP 6 Add details to the ray gun, clothing, and board. It turns out that the alien's bag is full of money! This space alien is an intergalactic bank robber!

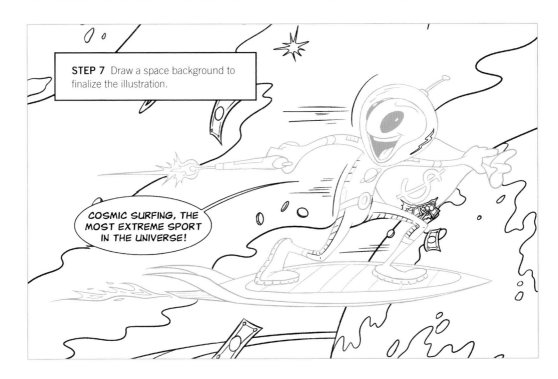

STEP 7 Draw a space background to finalize the illustration.

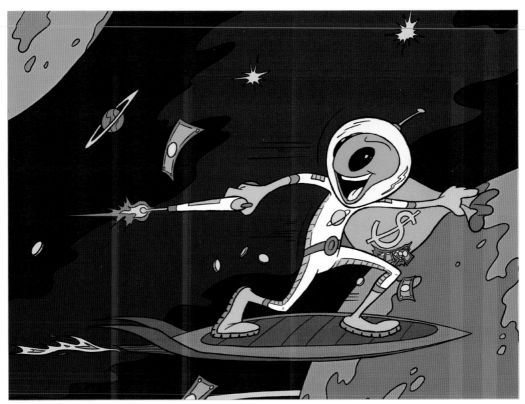

STEP 8 All that's left is to ink and color the drawing, and our cartoon space alien is ready to take off on sci-fi adventures!

ASTRONAUT

DIFFICULTY LEVEL: ★★★★☆

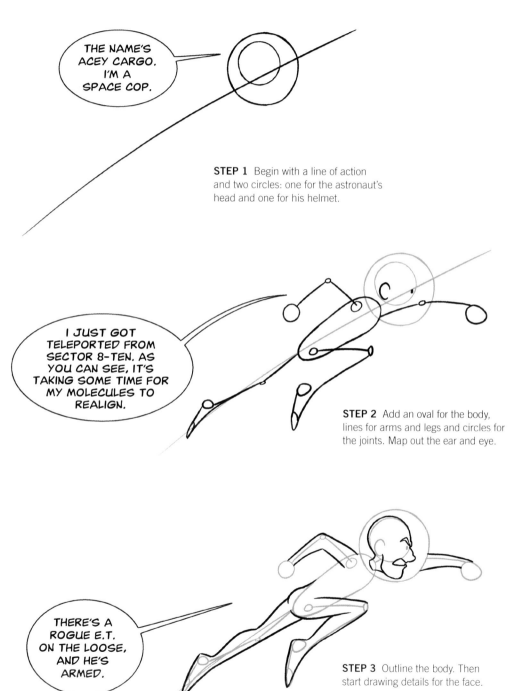

THE NAME'S ACEY CARGO. I'M A SPACE COP.

STEP 1 Begin with a line of action and two circles: one for the astronaut's head and one for his helmet.

I JUST GOT TELEPORTED FROM SECTOR 8-TEN. AS YOU CAN SEE, IT'S TAKING SOME TIME FOR MY MOLECULES TO REALIGN.

STEP 2 Add an oval for the body, lines for arms and legs and circles for the joints. Map out the ear and eye.

THERE'S A ROGUE E.T. ON THE LOOSE, AND HE'S ARMED.

STEP 3 Outline the body. Then start drawing details for the face.

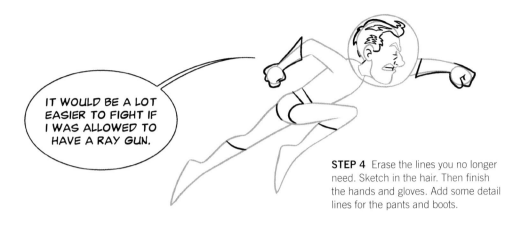

STEP 4 Erase the lines you no longer need. Sketch in the hair. Then finish the hands and gloves. Add some detail lines for the pants and boots.

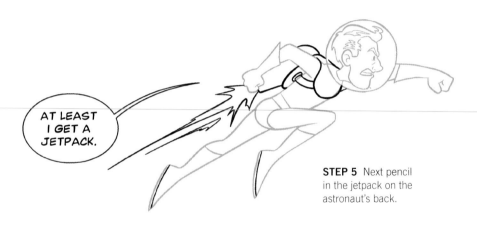

STEP 5 Next pencil in the jetpack on the astronaut's back.

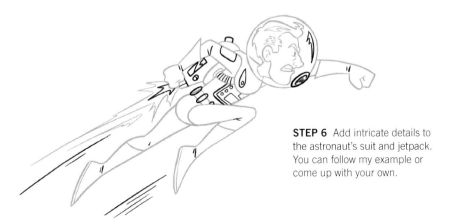

STEP 6 Add intricate details to the astronaut's suit and jetpack. You can follow my example or come up with your own.

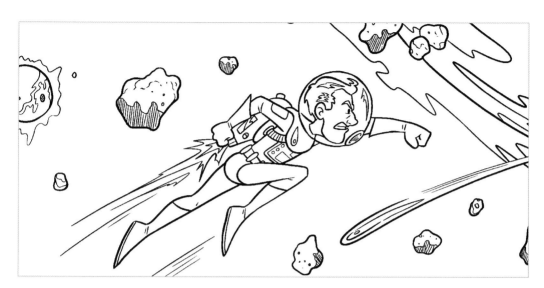

STEP 7 Add a cool space background and ink your cartoon.

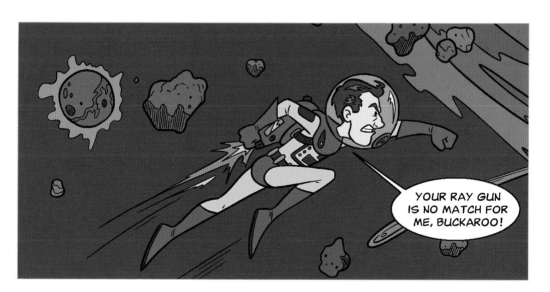

STEP 8 Finish by adding color. This space cop is officially ready to get down to business!

FLYING SAUCER

DIFFICULTY LEVEL: ★☆☆☆☆

STEP 1 Begin the saucer by drawing a circle with a line through it. Beneath the circle, add a curved line representing the outer edge of the spaceship.

STEP 2 Next draw three more curved lines. The first two lines form the metal trimming around the cockpit. The third line completes the bottom of the flying saucer.

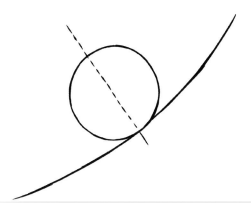

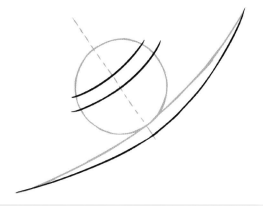

STEP 3 Add connecting lines to complete the outline. Then add the antennae on top.

STEP 4 Start adding some detail. Include a few panels on the ship, a couple of rivets, a highlight on the cockpit glass, and more trimming.

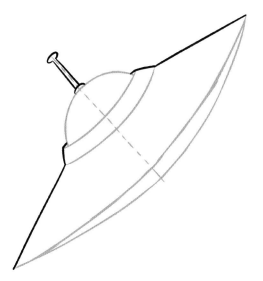

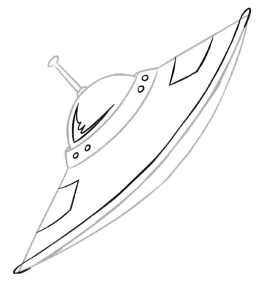

STEP 5 Add the final details below and few background props, and your flying saucer is ready to zip from galaxy to galaxy.

GILESE 581C

ALPHA CENTAURI

LIGHT VELOCITY COIL UPTAKE VALVE NO.3

EXOPLANET

GRAPHENE FIBER COCKPIT

LACILLE 8760

HIGGS BOSON ACCELERATOR PANEL

ELECTROPLASMIC SWITCH

ERGONOMIC TRANSMORPHIC NEUTRON BATTERY

HUMANE HUMAN ABDUCTION BAY

PULSAR B2157+12

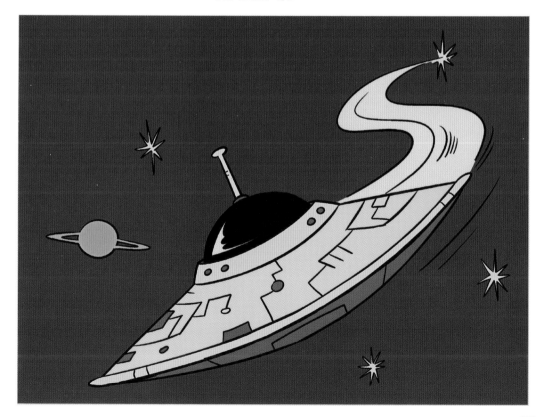

HOW TO DRAW
SUPERHEROES

SUPERHERO

DIFFICULTY LEVEL: ★★★☆☆

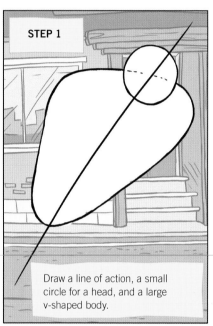

STEP 1

Draw a line of action, a small circle for a head, and a large v-shaped body.

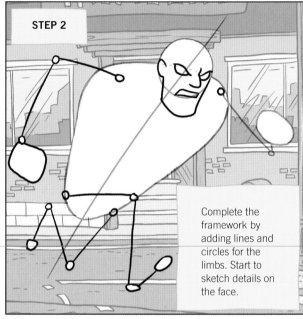

STEP 2

Complete the framework by adding lines and circles for the limbs. Start to sketch details on the face.

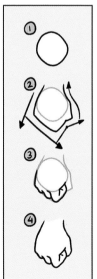

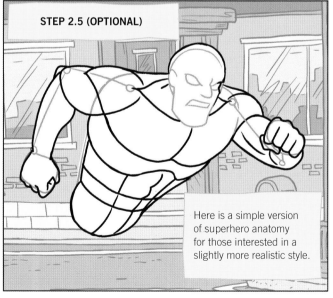

STEP 2.5 (OPTIONAL)

Here is a simple version of superhero anatomy for those interested in a slightly more realistic style.

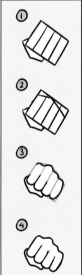

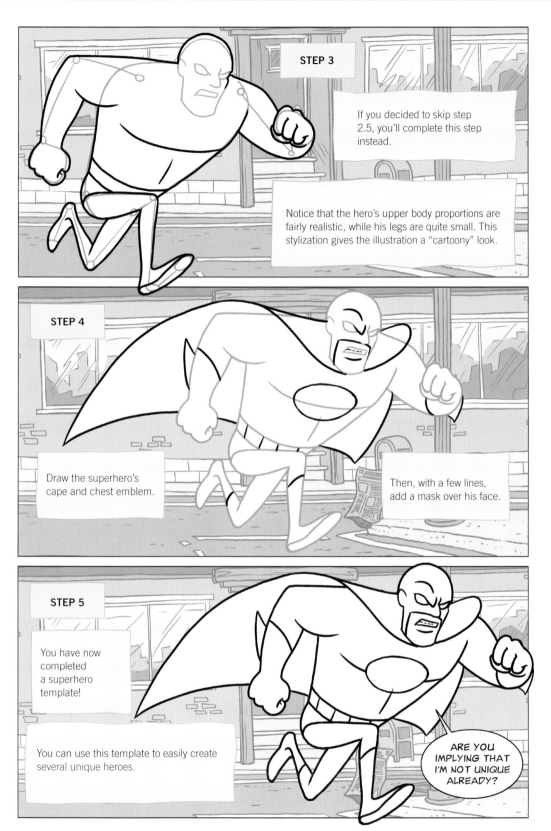

STEP 3

If you decided to skip step 2.5, you'll complete this step instead.

Notice that the hero's upper body proportions are fairly realistic, while his legs are quite small. This stylization gives the illustration a "cartoony" look.

STEP 4

Draw the superhero's cape and chest emblem.

Then, with a few lines, add a mask over his face.

STEP 5

You have now completed a superhero template!

You can use this template to easily create several unique heroes.

ARE YOU IMPLYING THAT I'M NOT UNIQUE ALREADY?

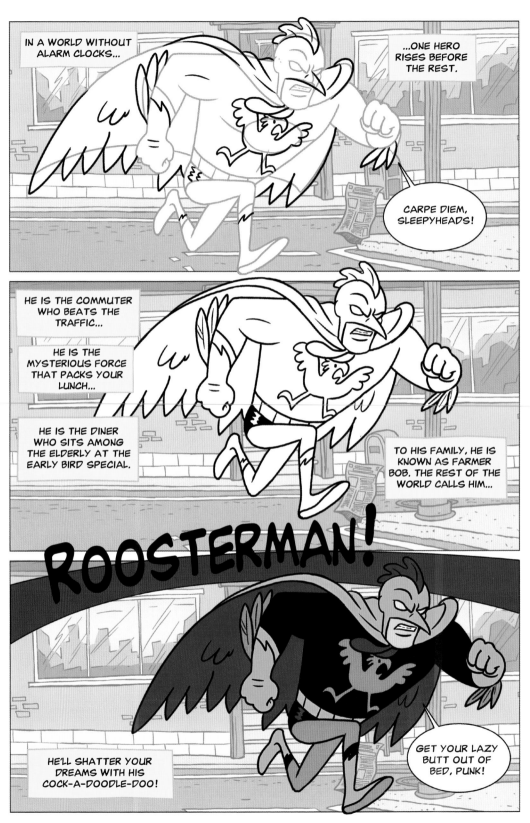

SUPERHEROINE

DIFFICULTY LEVEL: ★★☆☆☆

STEP 1: DRAW THE HEAD Follow this mini-tutorial demonstrating how to draw an attractive female face.

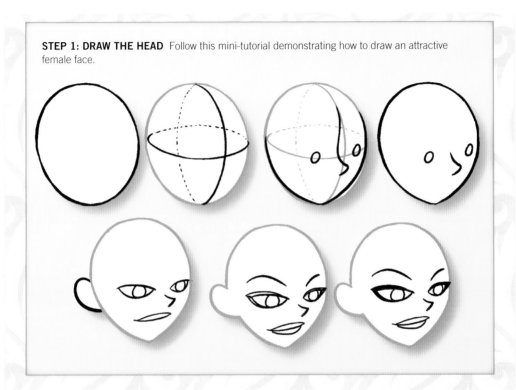

STEP 2: CREATE THE FRAMEWORK Now draw the body of this cartoon heroine.

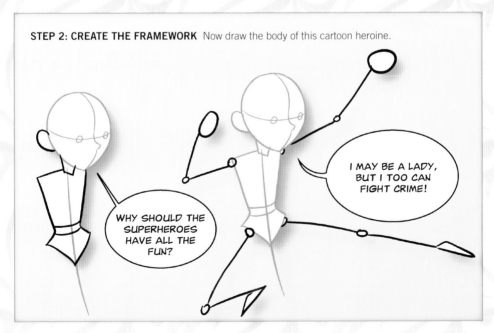

WHY SHOULD THE SUPERHEROES HAVE ALL THE FUN?

I MAY BE A LADY, BUT I TOO CAN FIGHT CRIME!

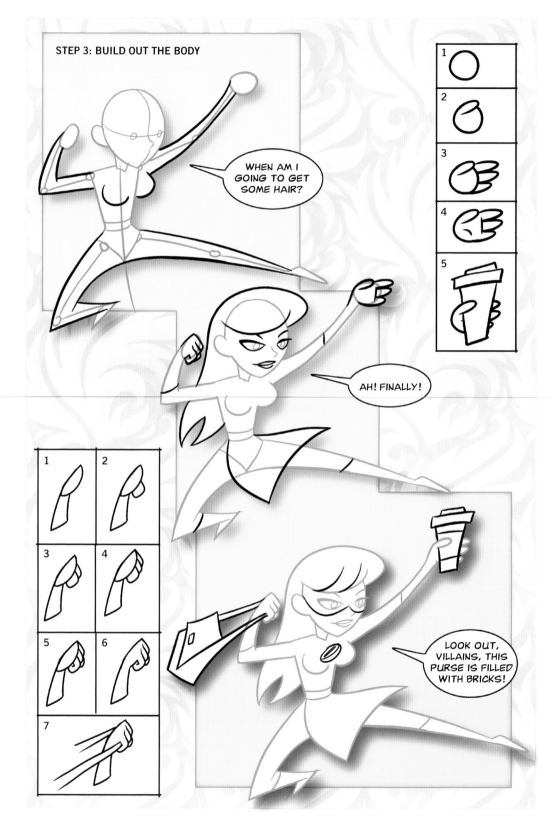

STEP 3: BUILD OUT THE BODY

Mild-mannered Susie Fleming calmly starts her day shift at the local coffee shop. Fifty-one lattes later, her caffeine-induced superpowers kick in, transforming her into...

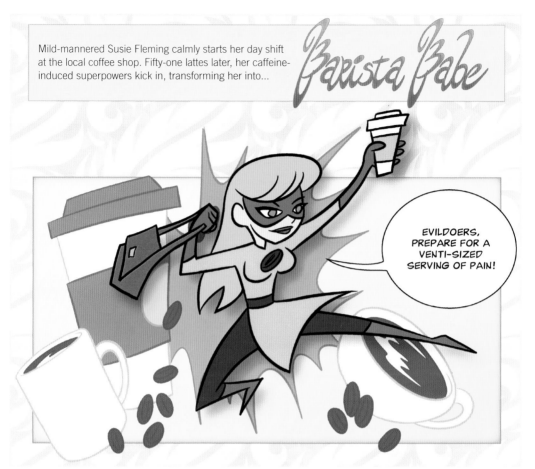

BONUS EXERCISE

Once you've completed the first version of Barista Babe, try using the same steps to draw her in a more realistic style.

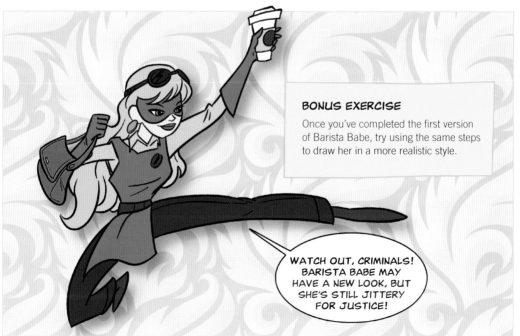

BURGLAR

DIFFICULTY LEVEL: ★★☆☆☆

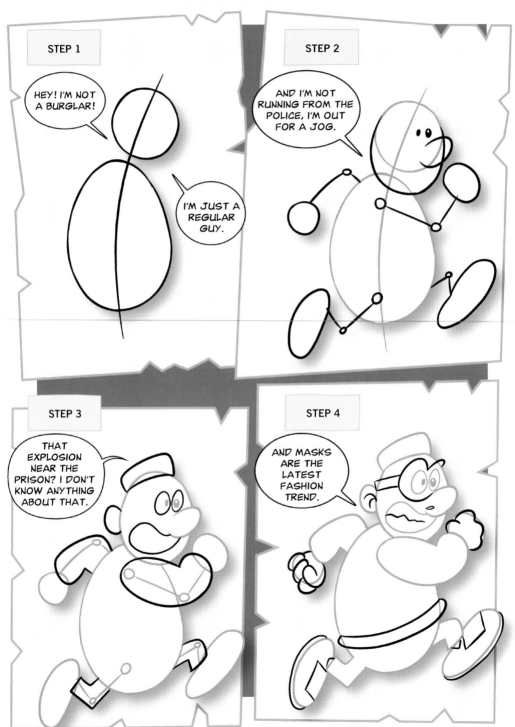

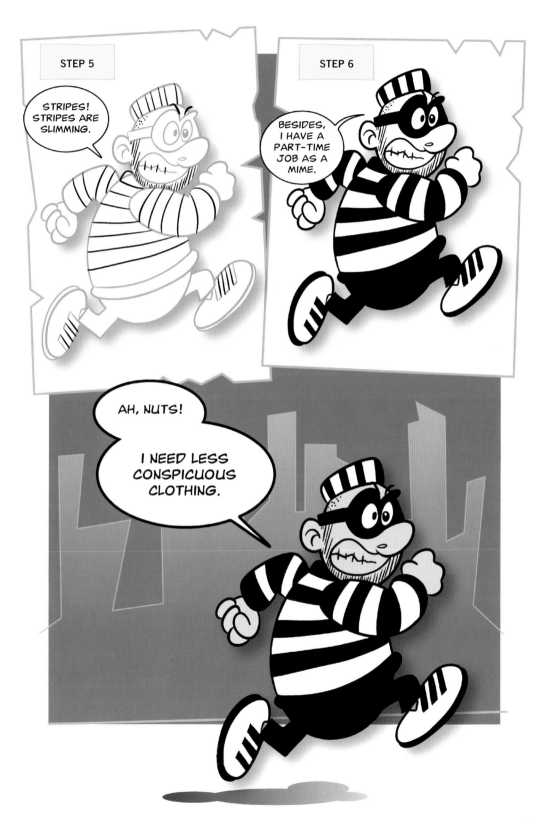

THE END

I HOPE THIS BOOK HAS GIVEN YOU SOME INSIGHT INTO THE CARTOONING PROCESS.

AS THESE TUTORIALS HAVE SHOWN, BENEATH THE CUTE AND SILLY CHARACTERS LIES A BASIC STRUCTURE THAT CAN BE USED AGAIN AND AGAIN.

WITH PATIENCE AND PRACTICE, YOU TOO WILL BE ABLE TO MASTER THIS INSPIRING ART FORM.

AND IF AT ANY POINT YOU GET STUCK OR FEEL LIKE GIVING UP, JUST REMEMBER THAT QUOTE BY SOME FAMOUS GUY.

UH...WHO WAS IT AGAIN?

WINSTON CHURCHILL.

OH YEAH. AND WHAT DID HE SAY?

NEVER GIVE IN. NEVER GIVE IN. NEVER, NEVER, NEVER, NEVER—IN NOTHING, GREAT OR SMALL, LARGE OR PETTY—NEVER GIVE IN!

WELL SAID, SIR! AND IF A QUOTE CAN BE APPLIED TO BOTH FIGHTING FOR GOOD AND CARTOONING...

...YOU KNOW IT'S SOUND ADVICE.